BROKEN HEARTS
TRUE LOVE
& OTHER TRAGEDIES

DEVIN SHEEHY

PORKOPOLIS PRODUCTIONS

CINCINNATI, OHIO

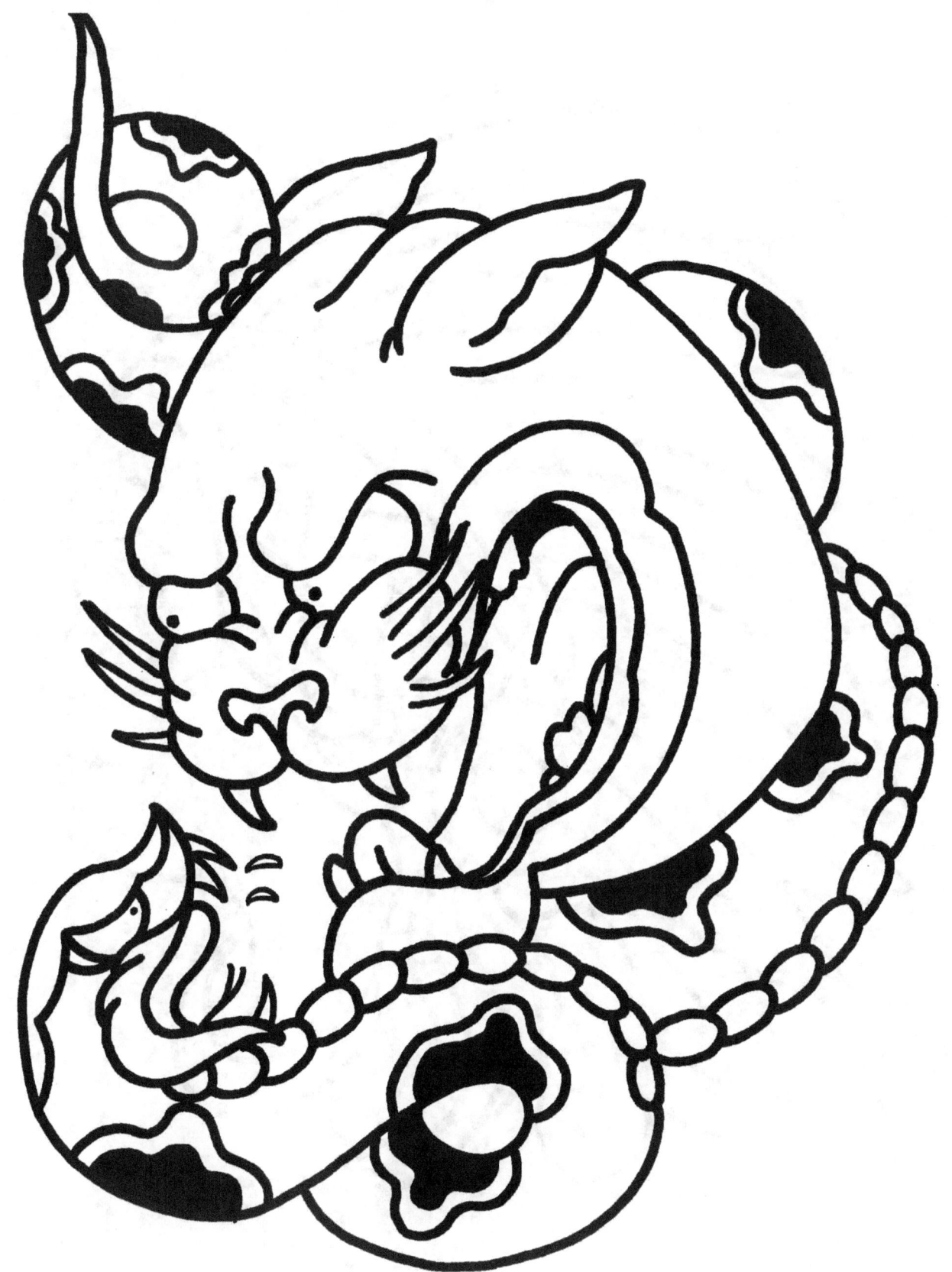

Broken Hearts, True Love & Other Tragedies

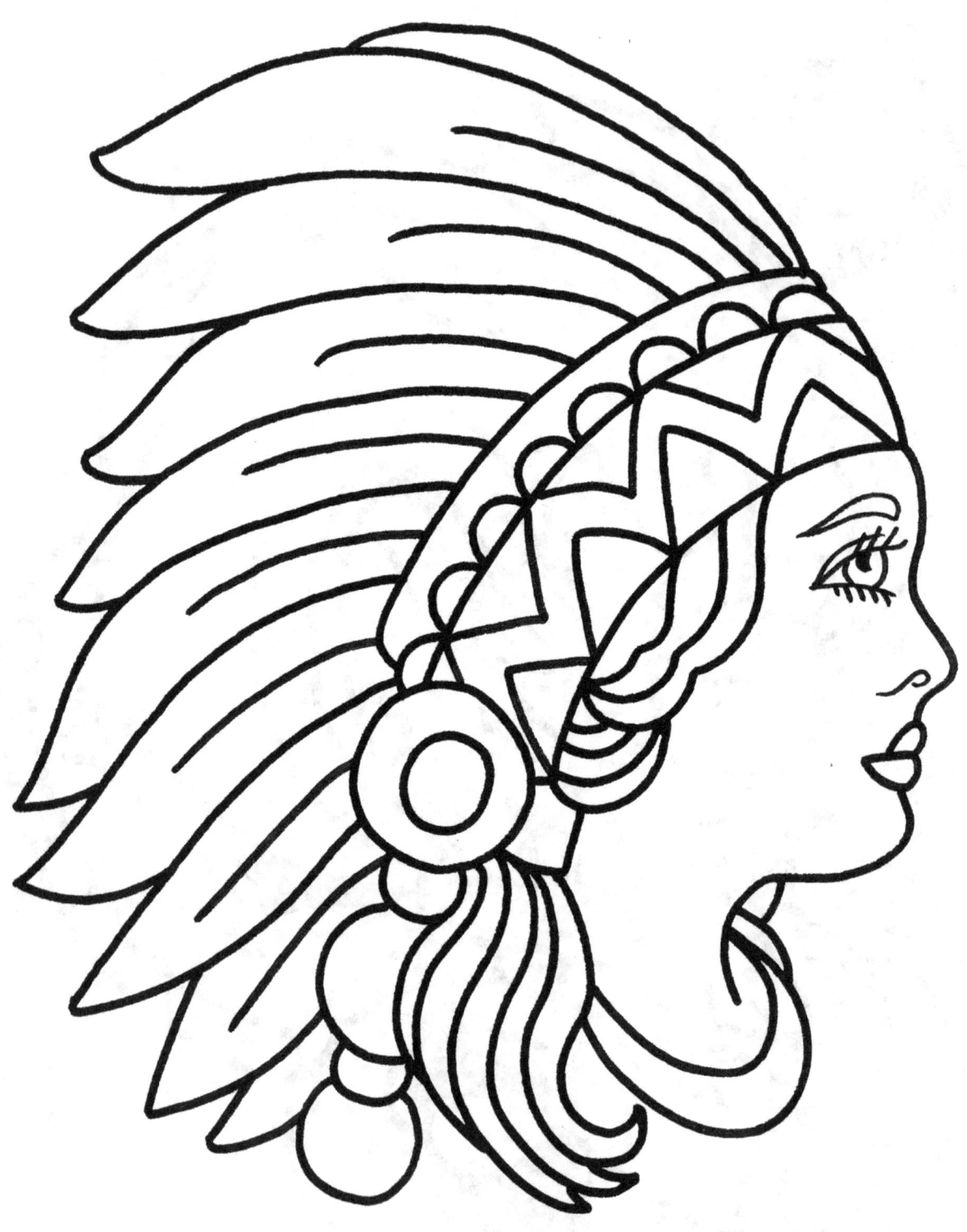

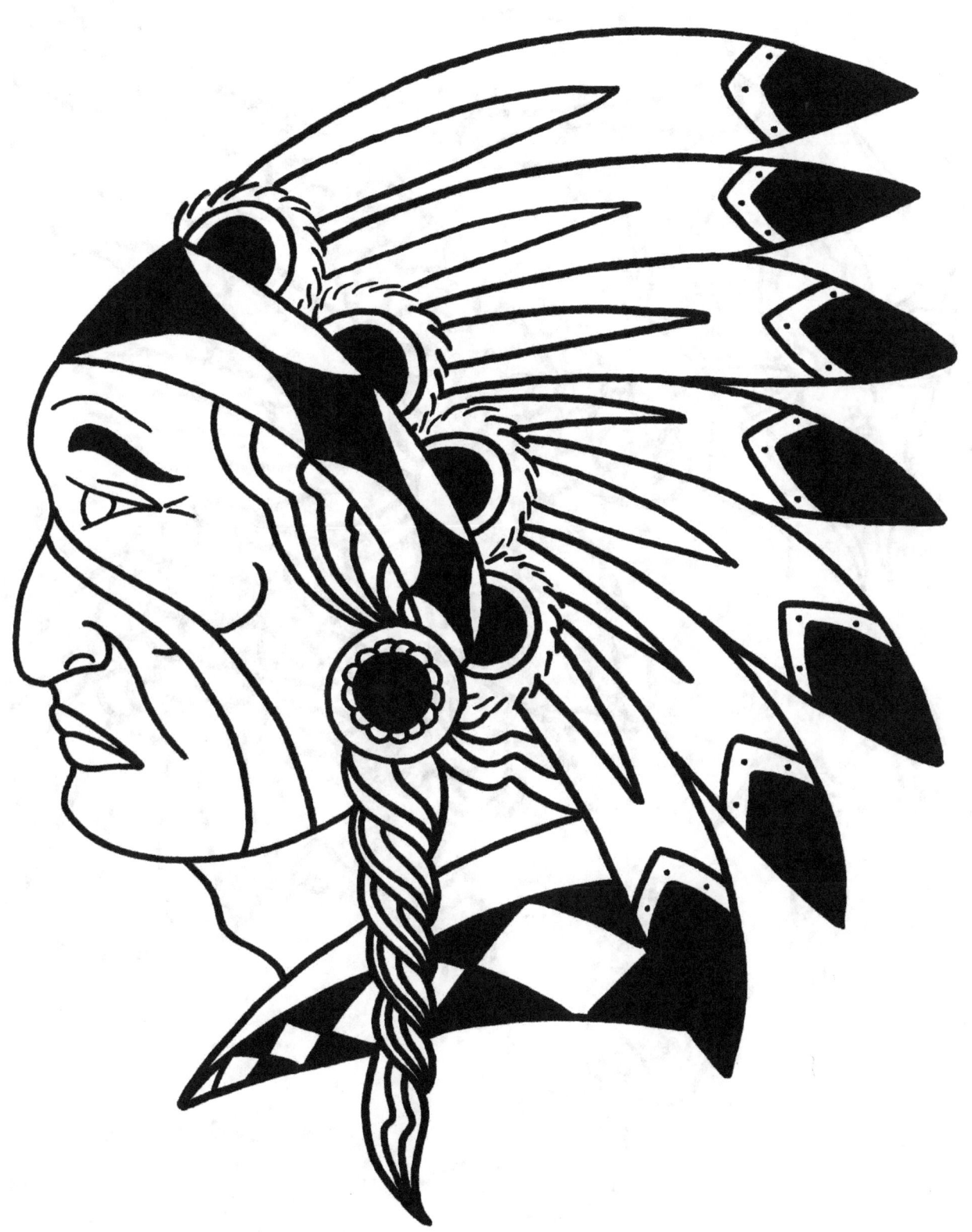

Broken Hearts, True Love & Other Tragedies

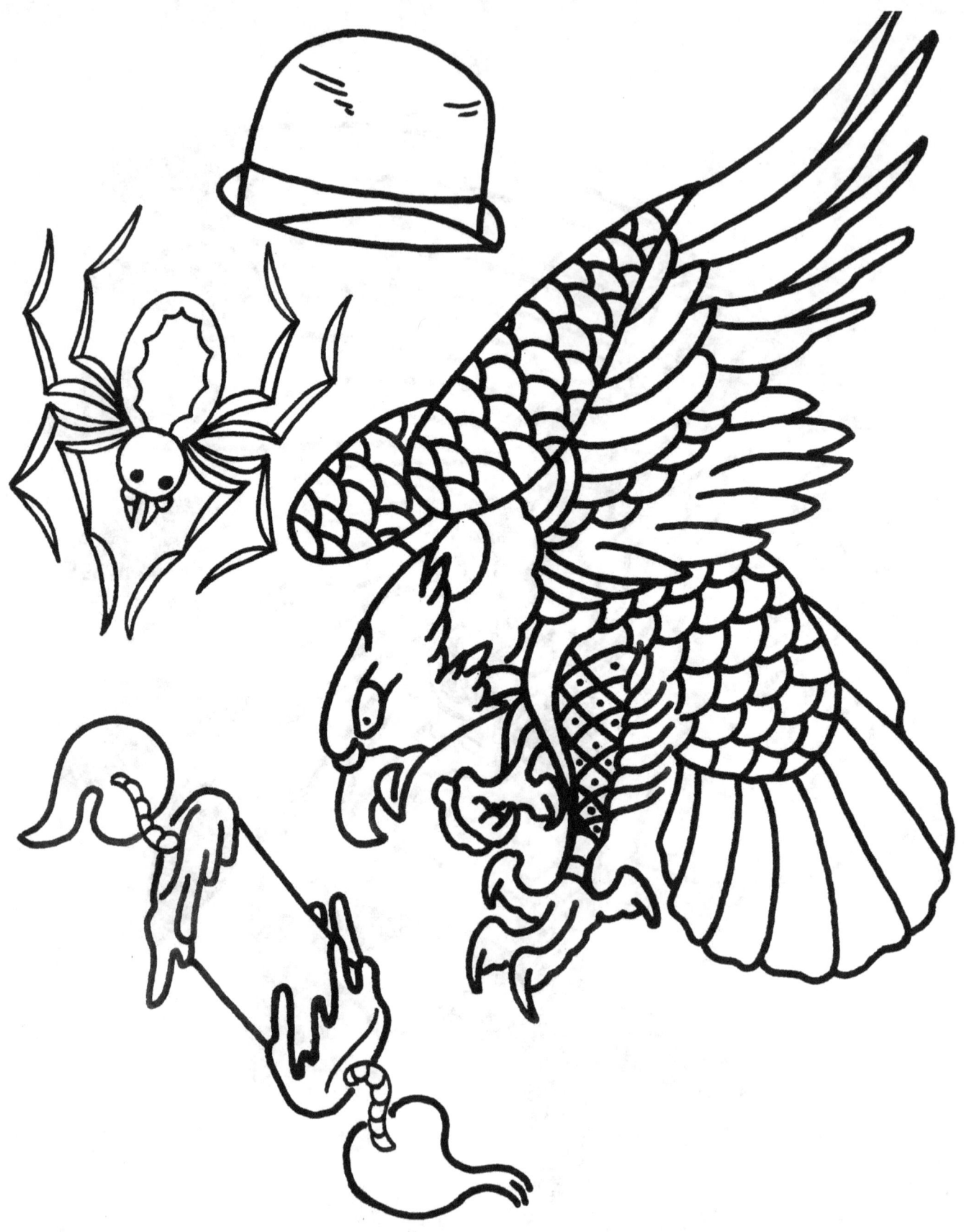

Devin Sheehy

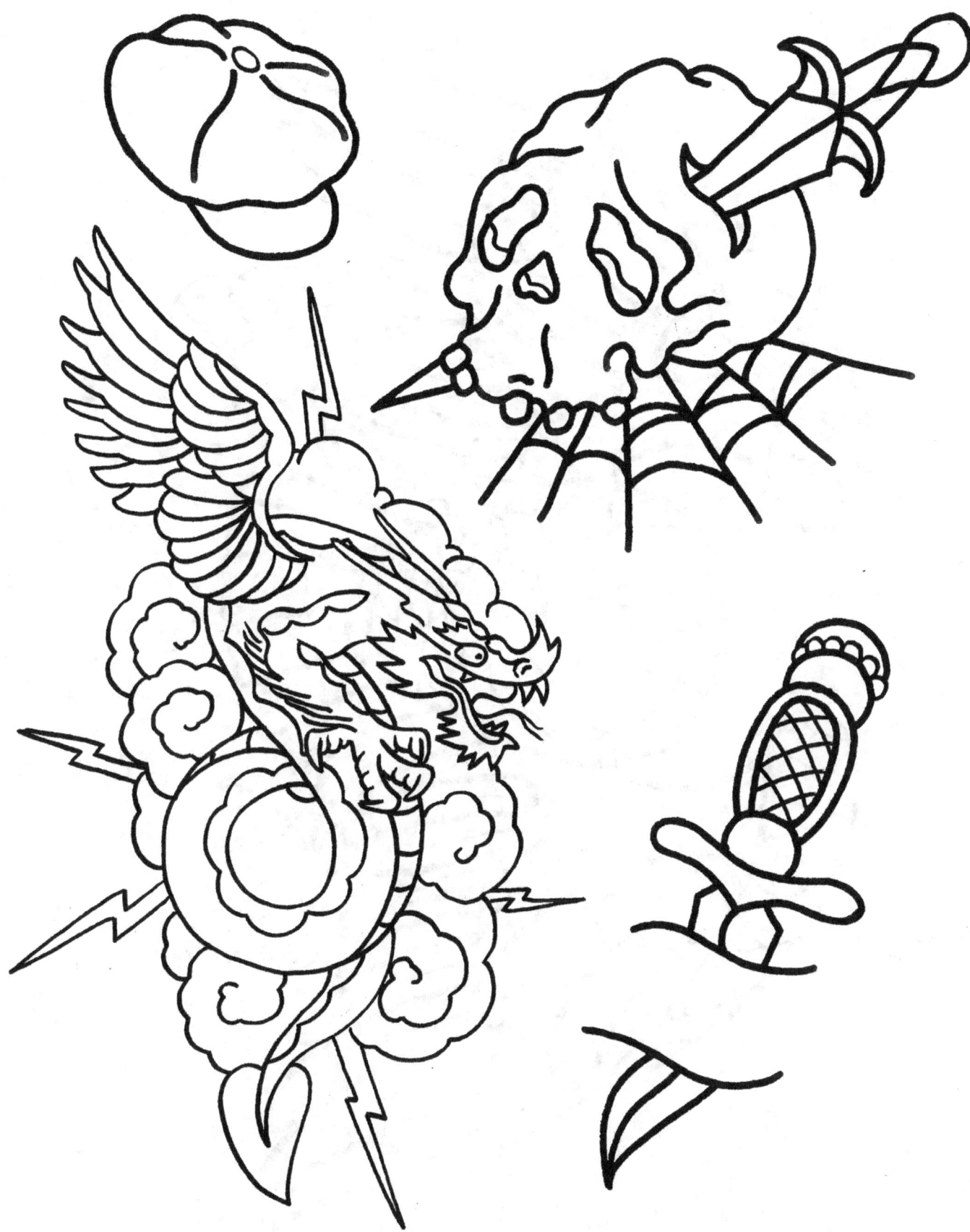

Broken Hearts, True Love & Other Tragedies

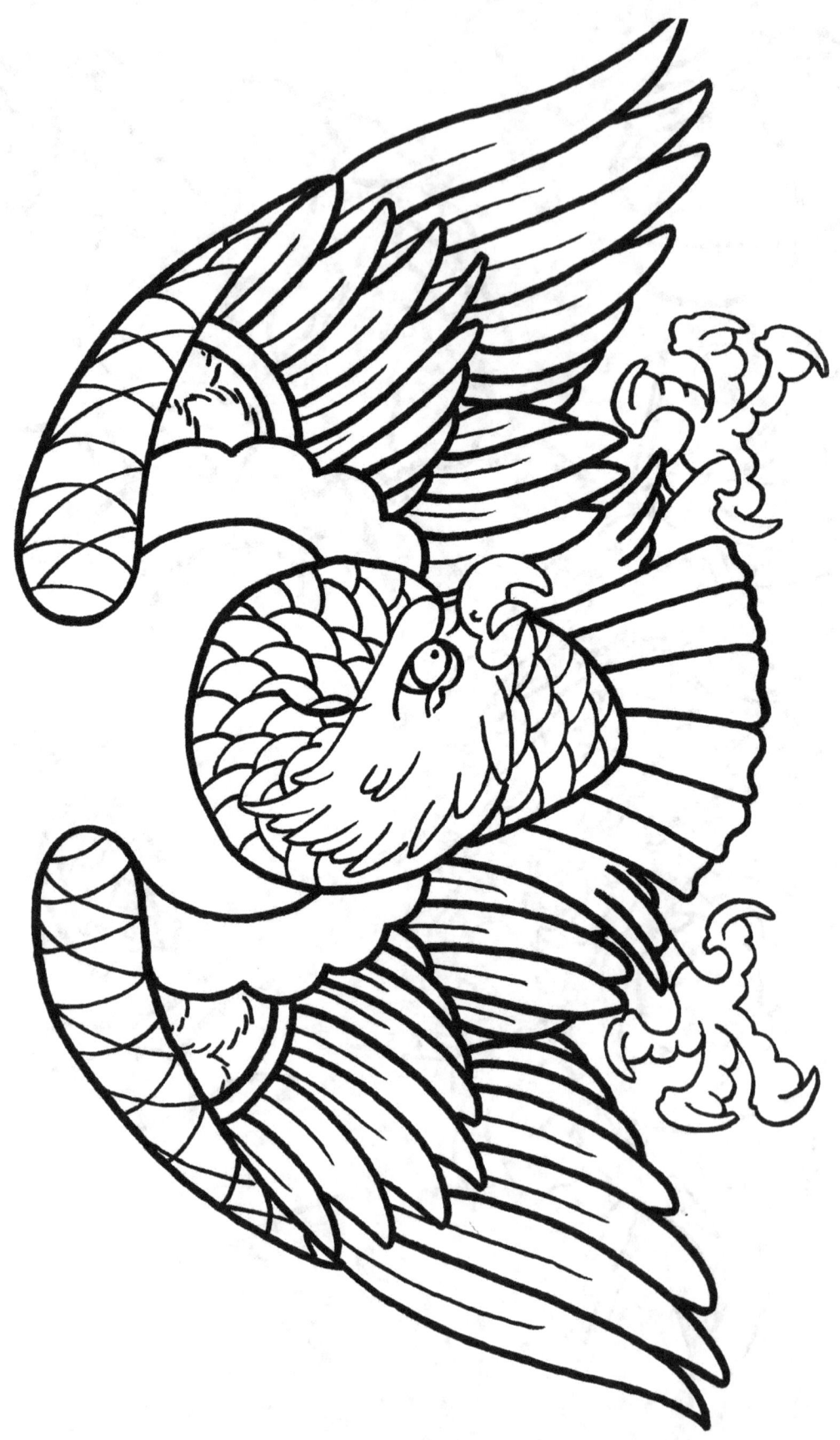

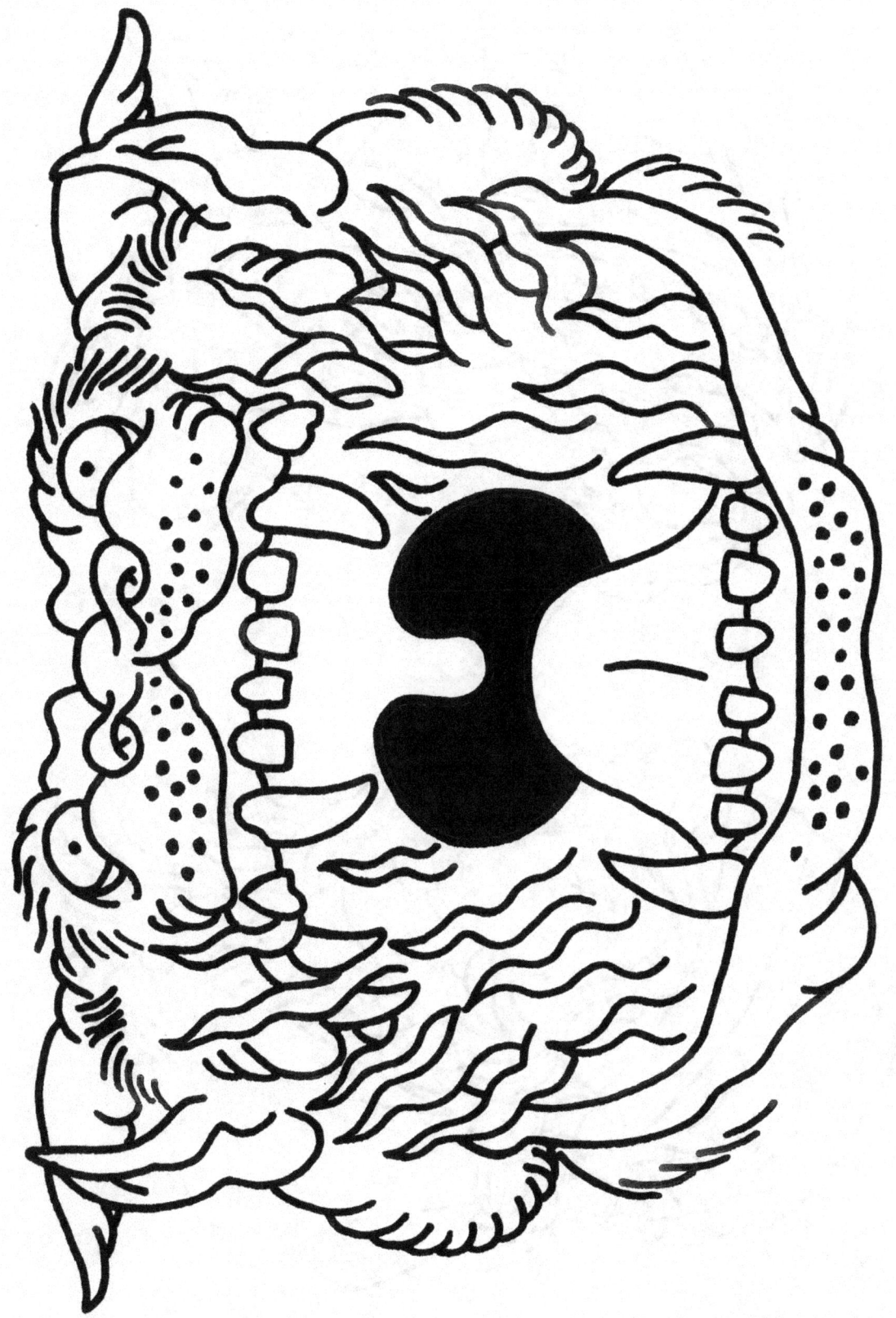

Broken Hearts, True Love & Other Tragedies

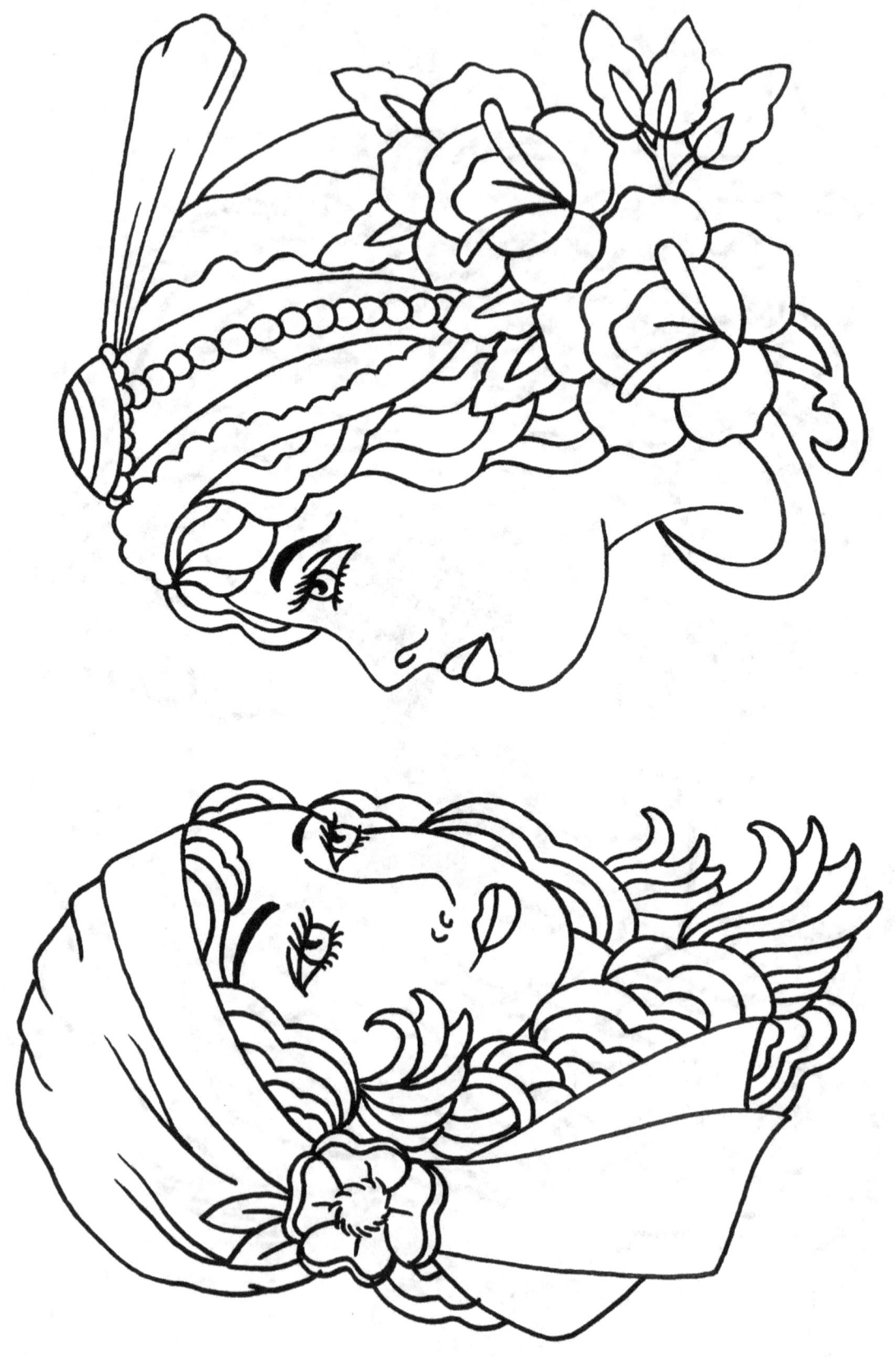

Devin Sheehy

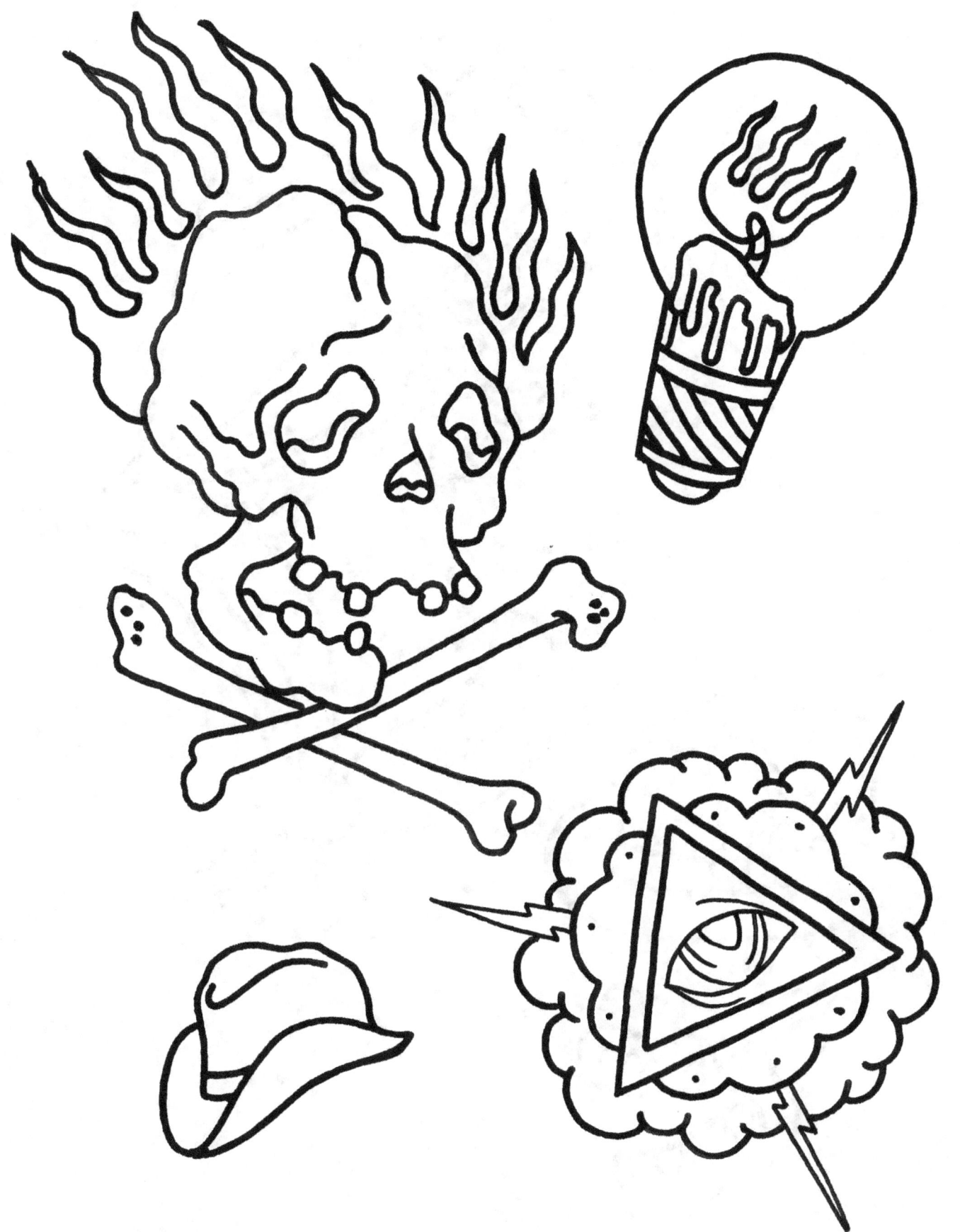

Broken Hearts, True Love & Other Tragedies

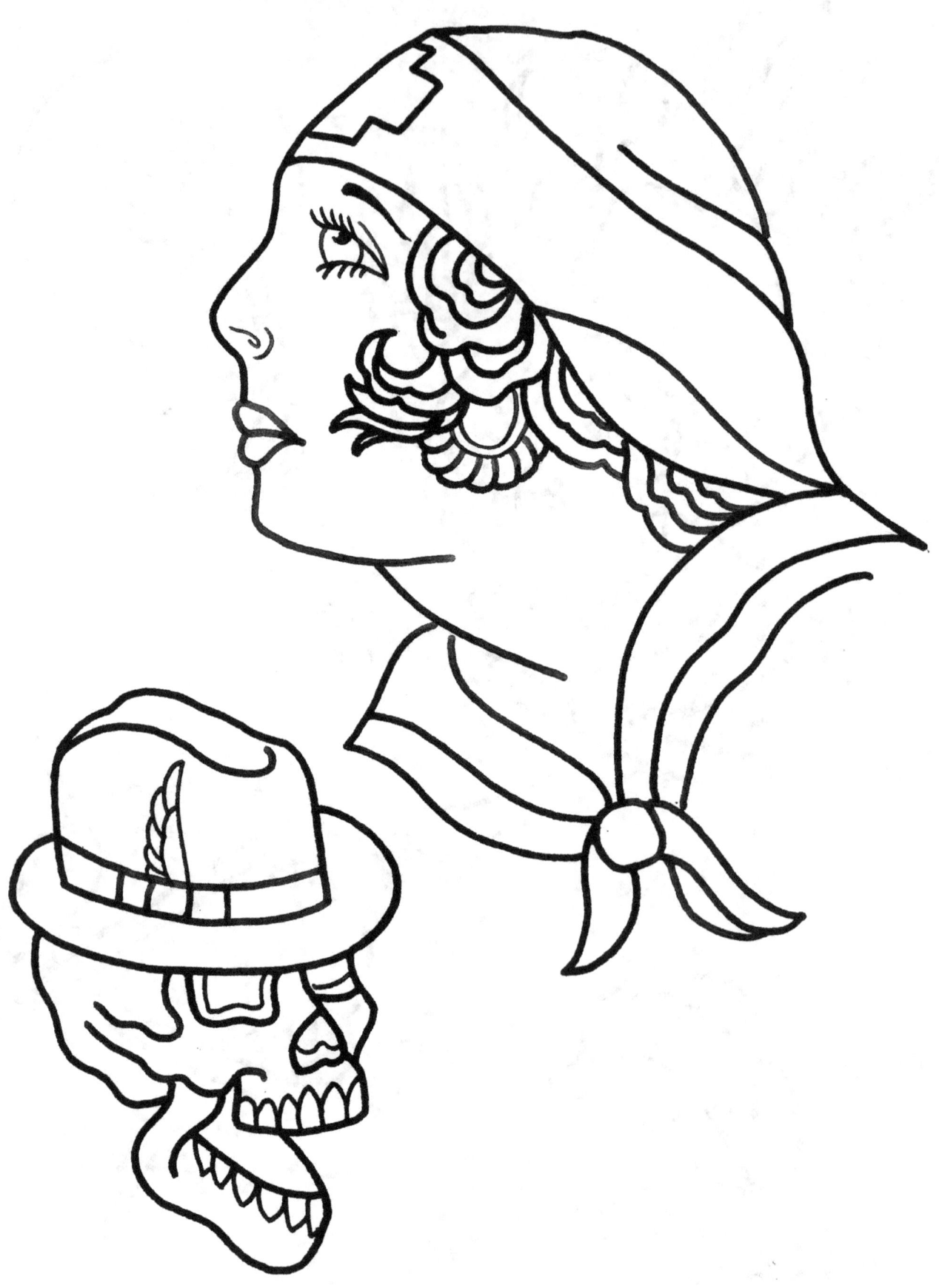

Devin Sheehy

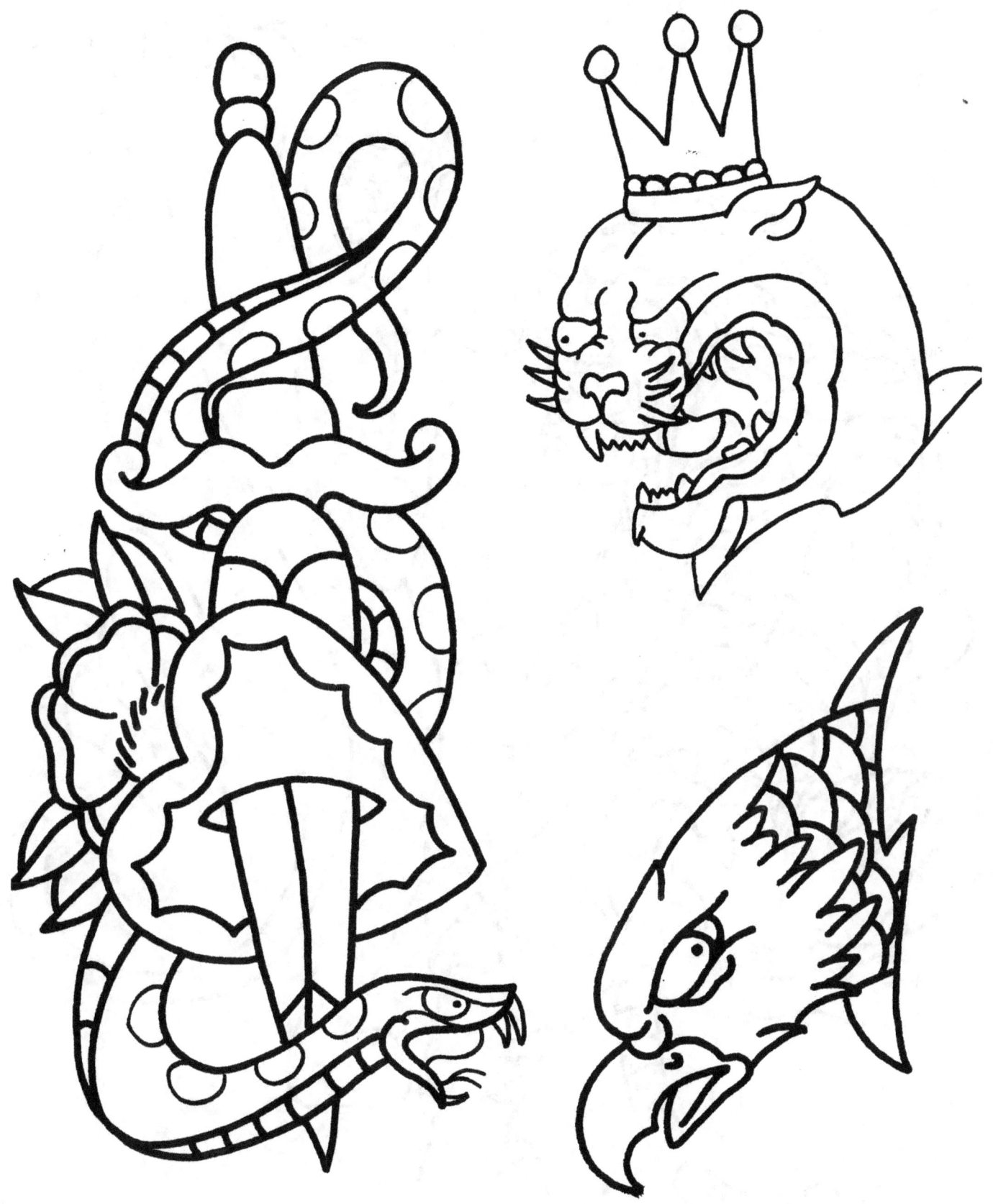

Broken Hearts, True Love & Other Tragedies

Devin Sheehy

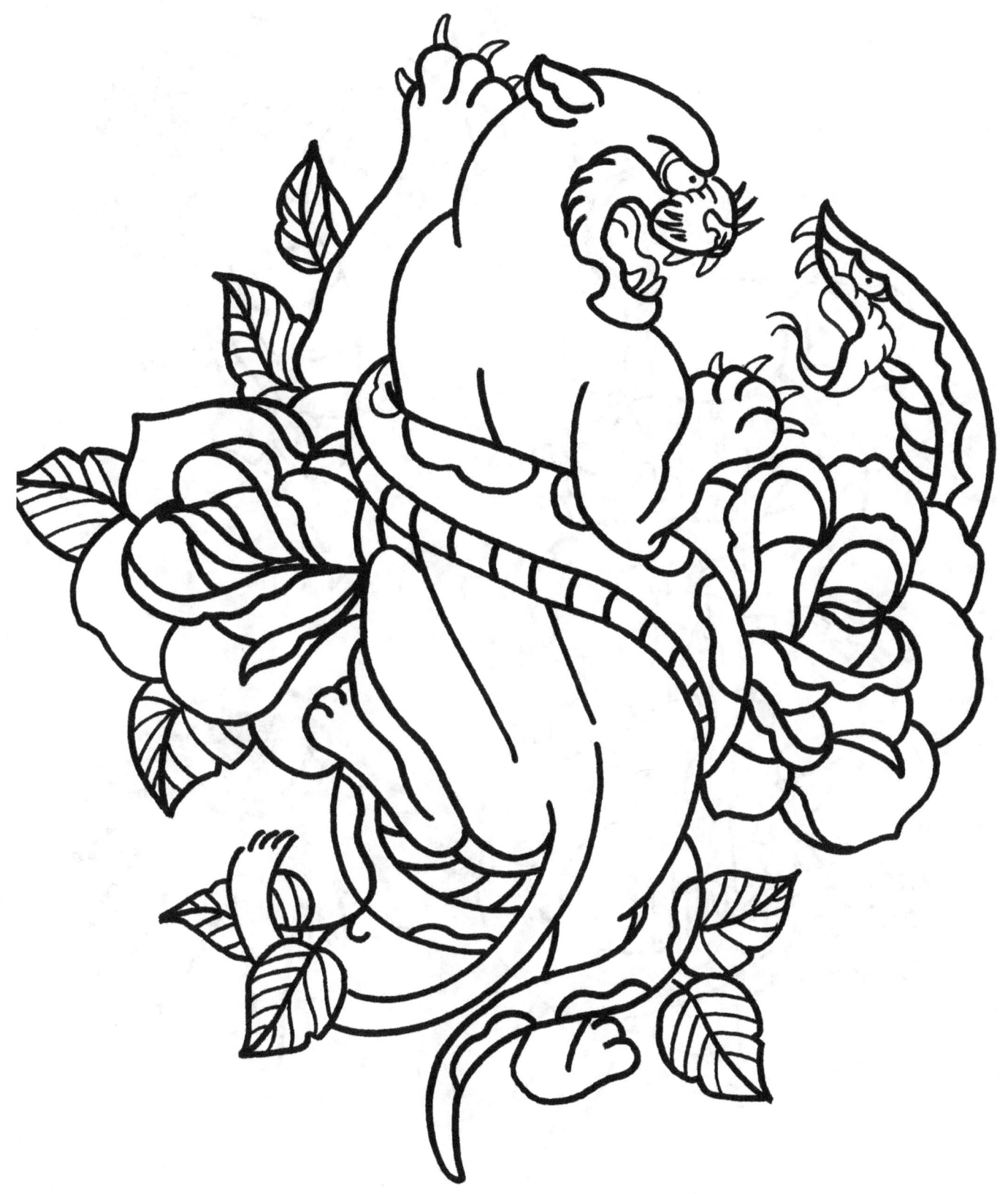

Broken Hearts, True Love & Other Tragedies

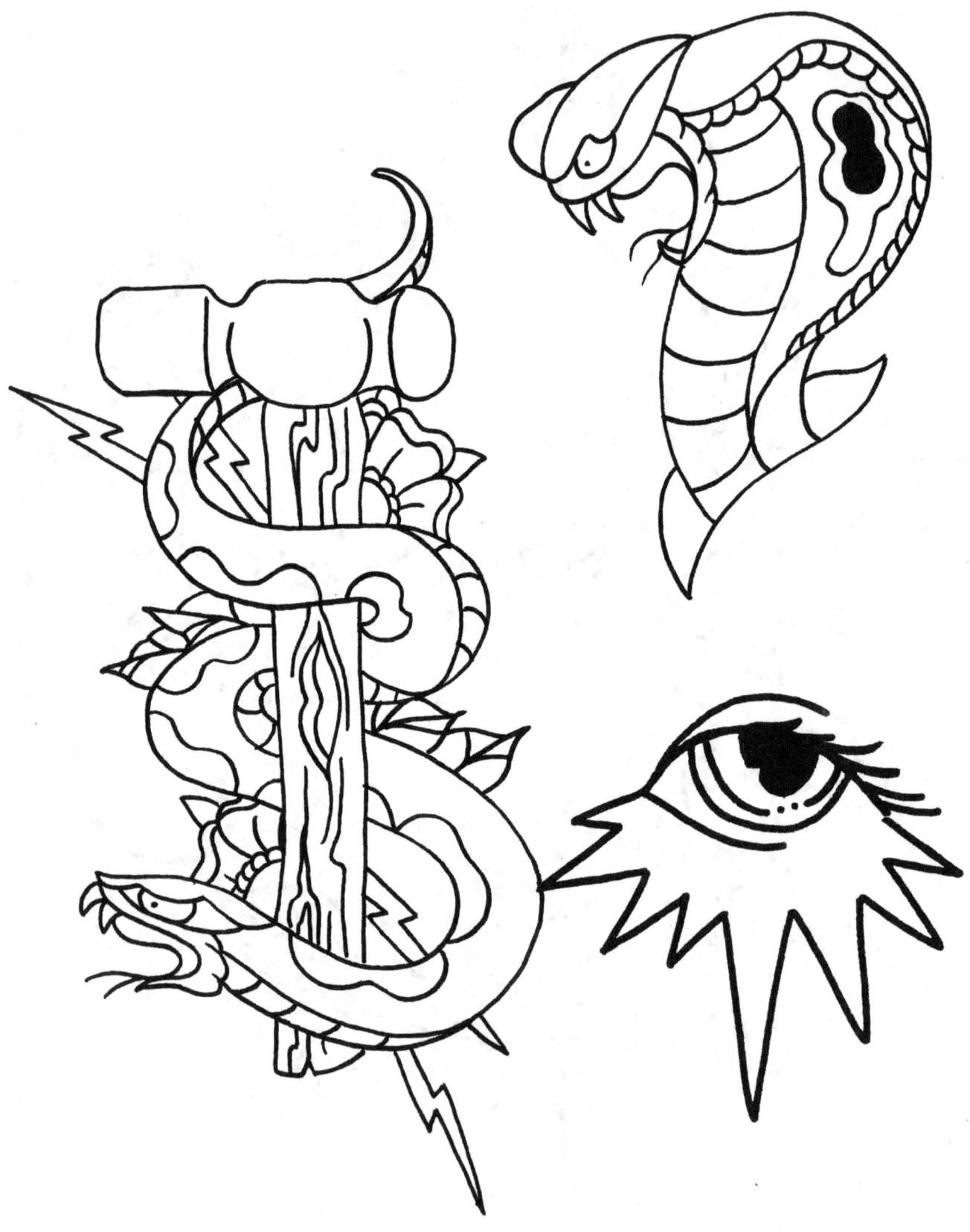

Devin Sheehy

15

Broken Hearts, True Love & Other Tragedies

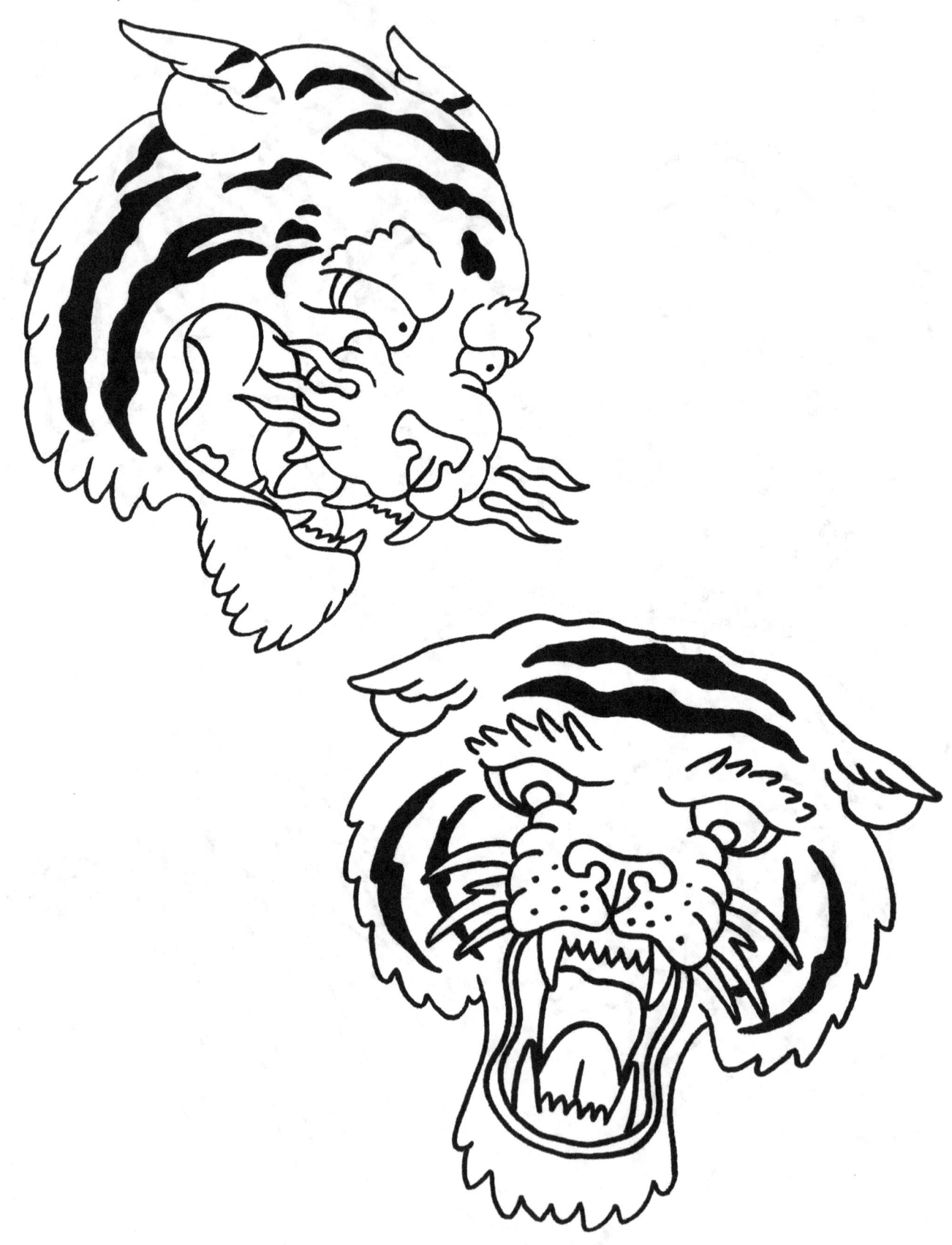

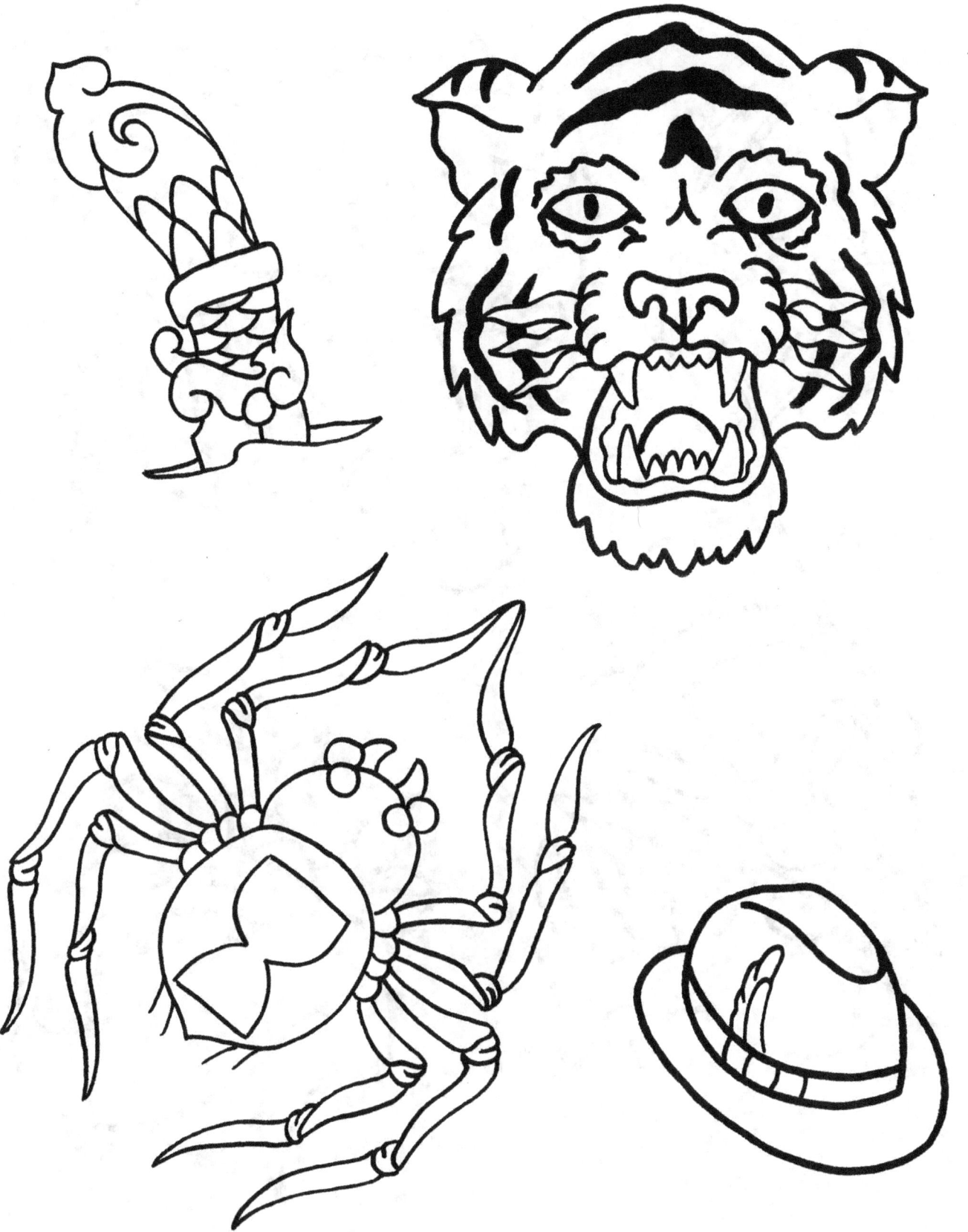

Broken Hearts, True Love & Other Tragedies

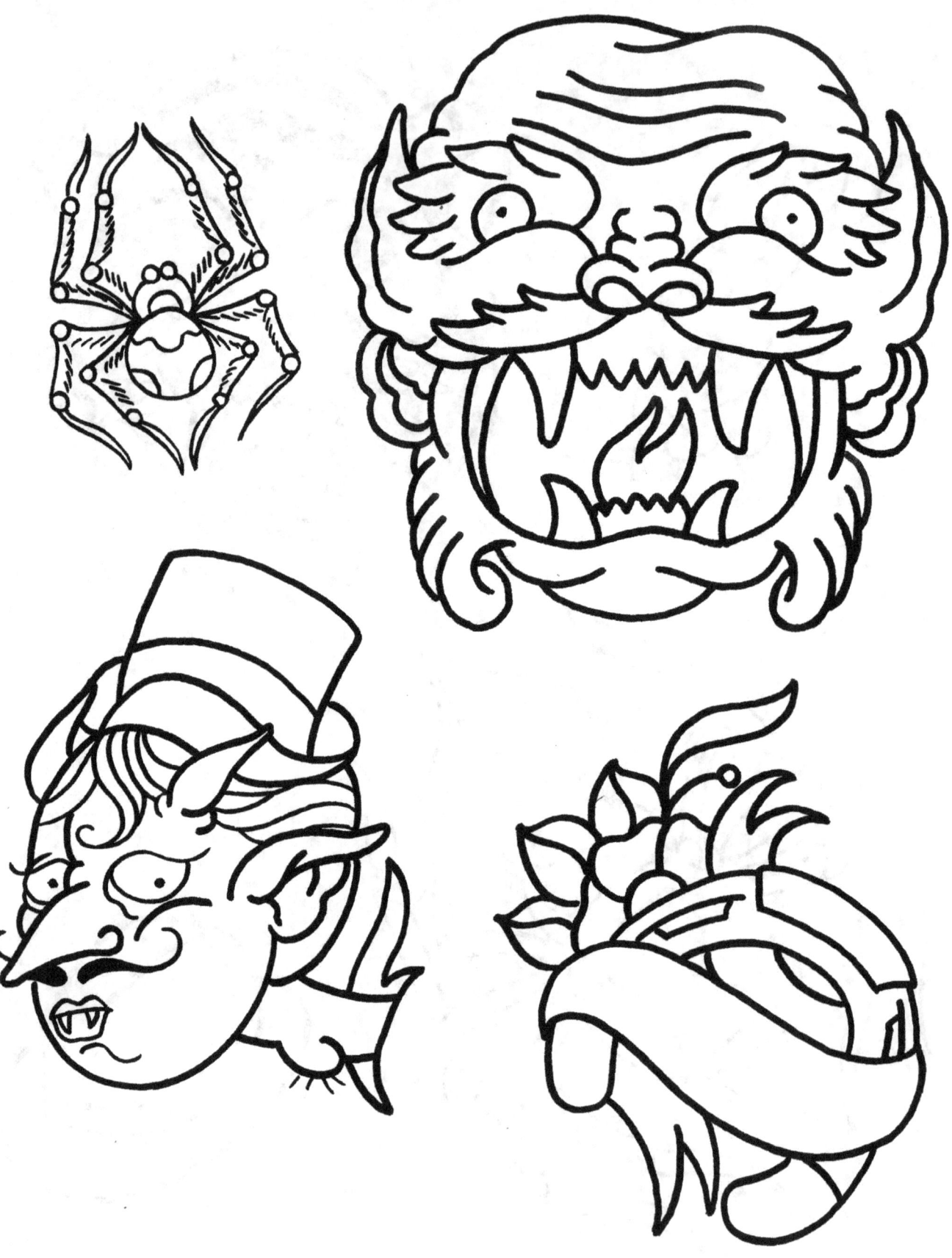

Devin Sheehy

Broken Hearts, True Love & Other Tragedies

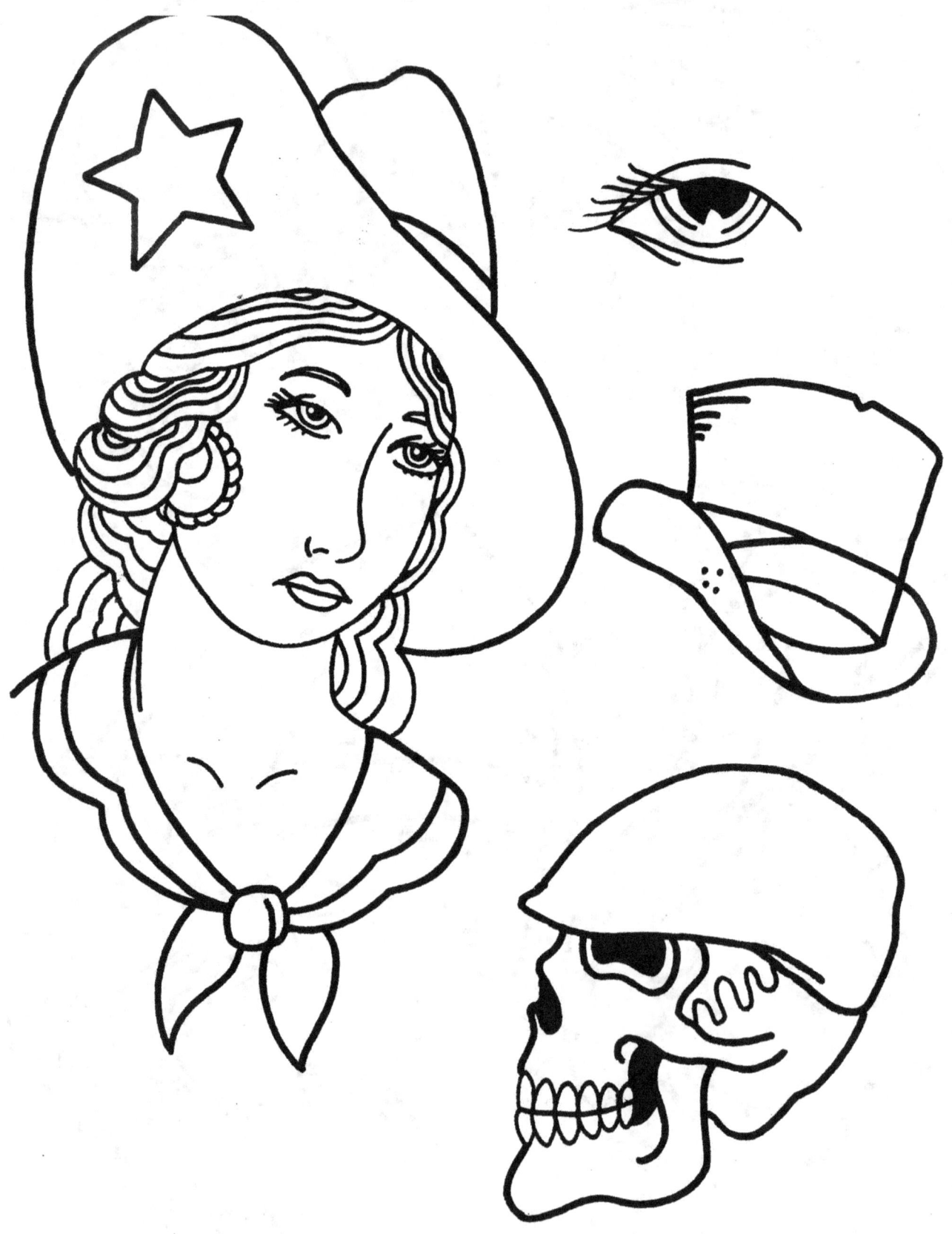

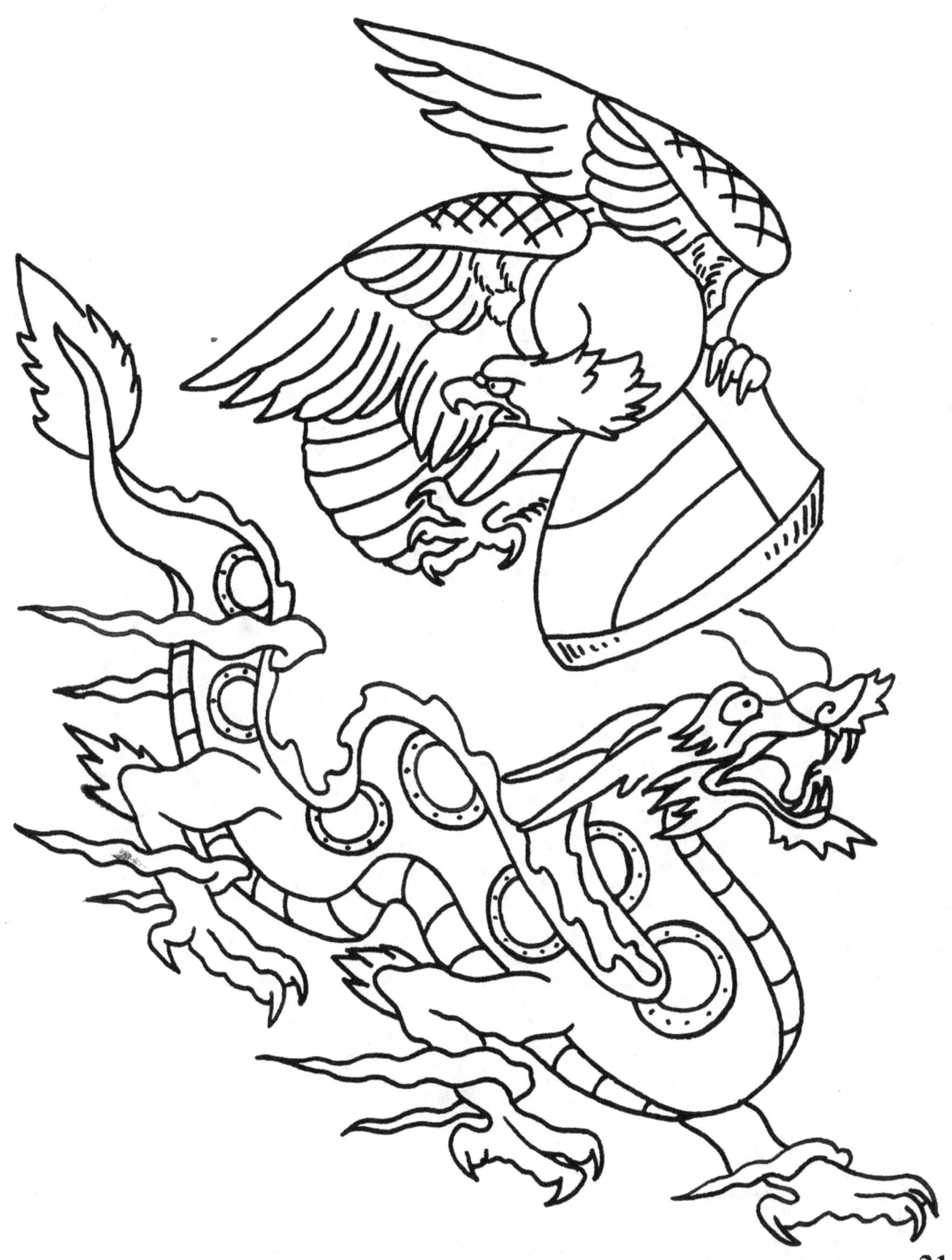

www.ingramcontent.com/pod-product-compliance
Lightning Source LLC
Chambersburg PA
CBHW081136180526
45170CB00008B/3122